The Heart Series

Collection One

As an artist, it is my hope to inspire, encourage, and uplift.
May my works speak peace and hope and joy to every heart,
and perhaps cause you to seek the One who gives true peace.

Cast All Your Cares

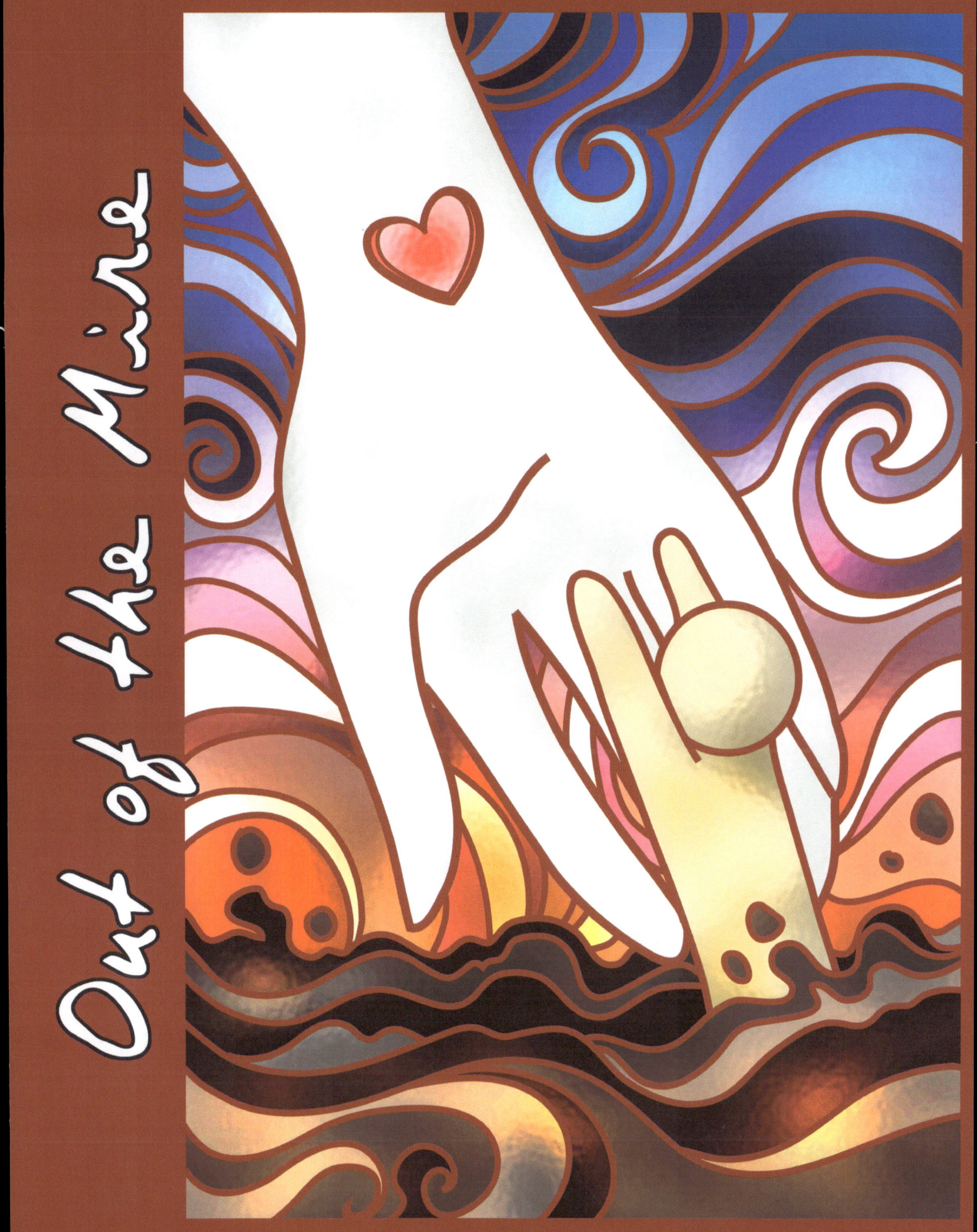

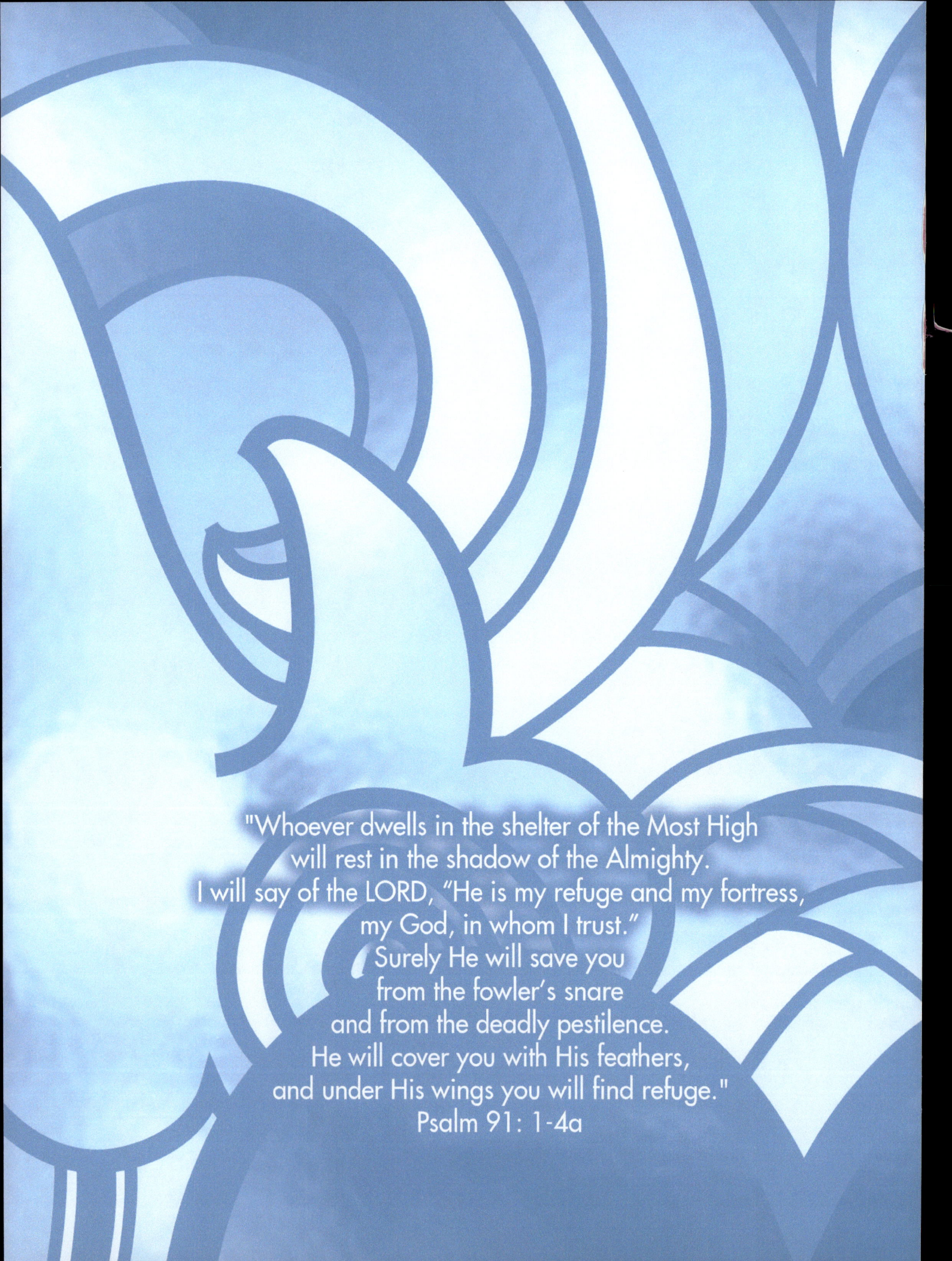

"Whoever dwells in the shelter of the Most High
will rest in the shadow of the Almighty.
I will say of the LORD, "He is my refuge and my fortress,
my God, in whom I trust."
Surely He will save you
from the fowler's snare
and from the deadly pestilence.
He will cover you with His feathers,
and under His wings you will find refuge."
Psalm 91: 1-4a

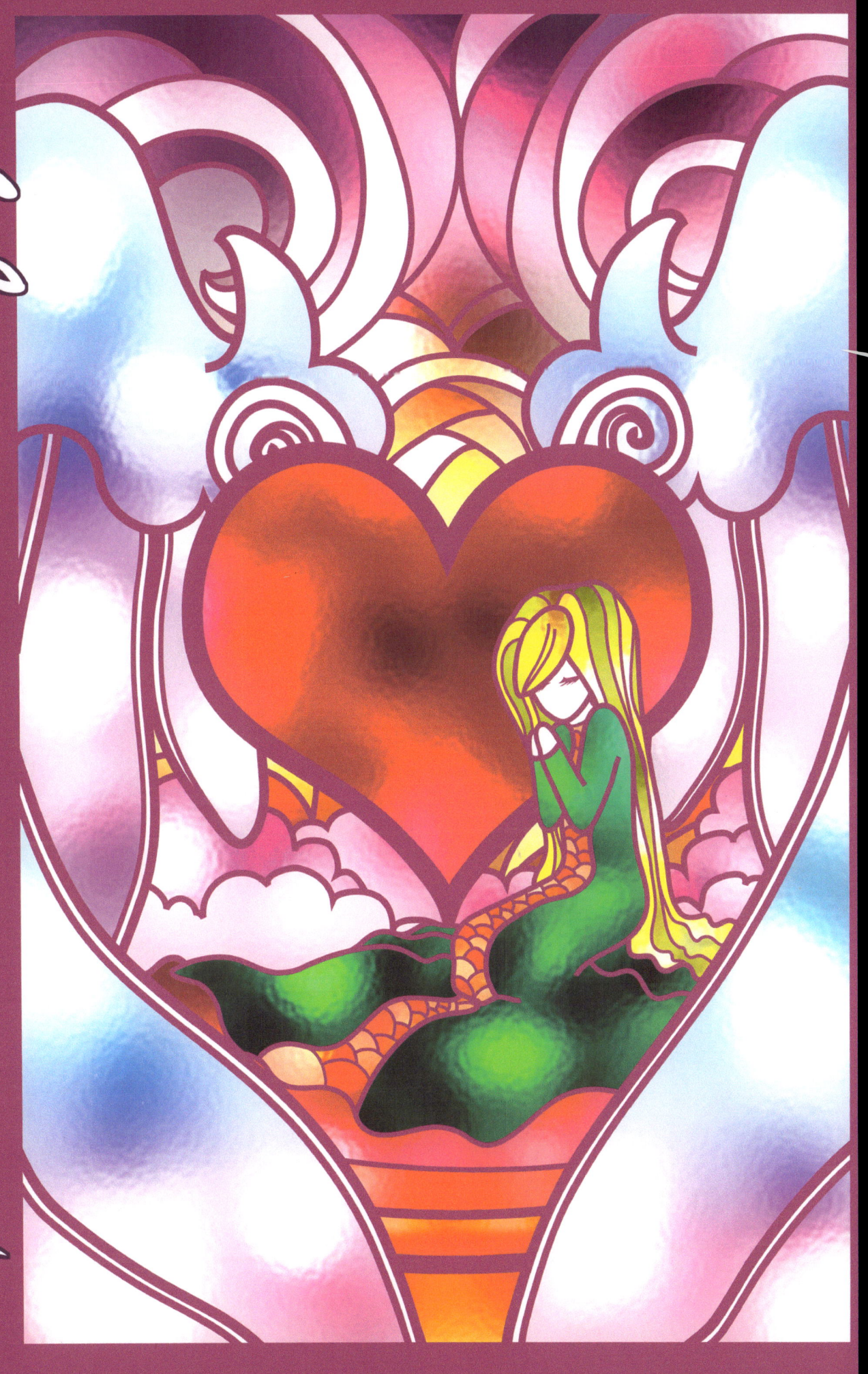

"Above all else, guard your heart,
for it is the wellspring of life."
Proverbs 4:23

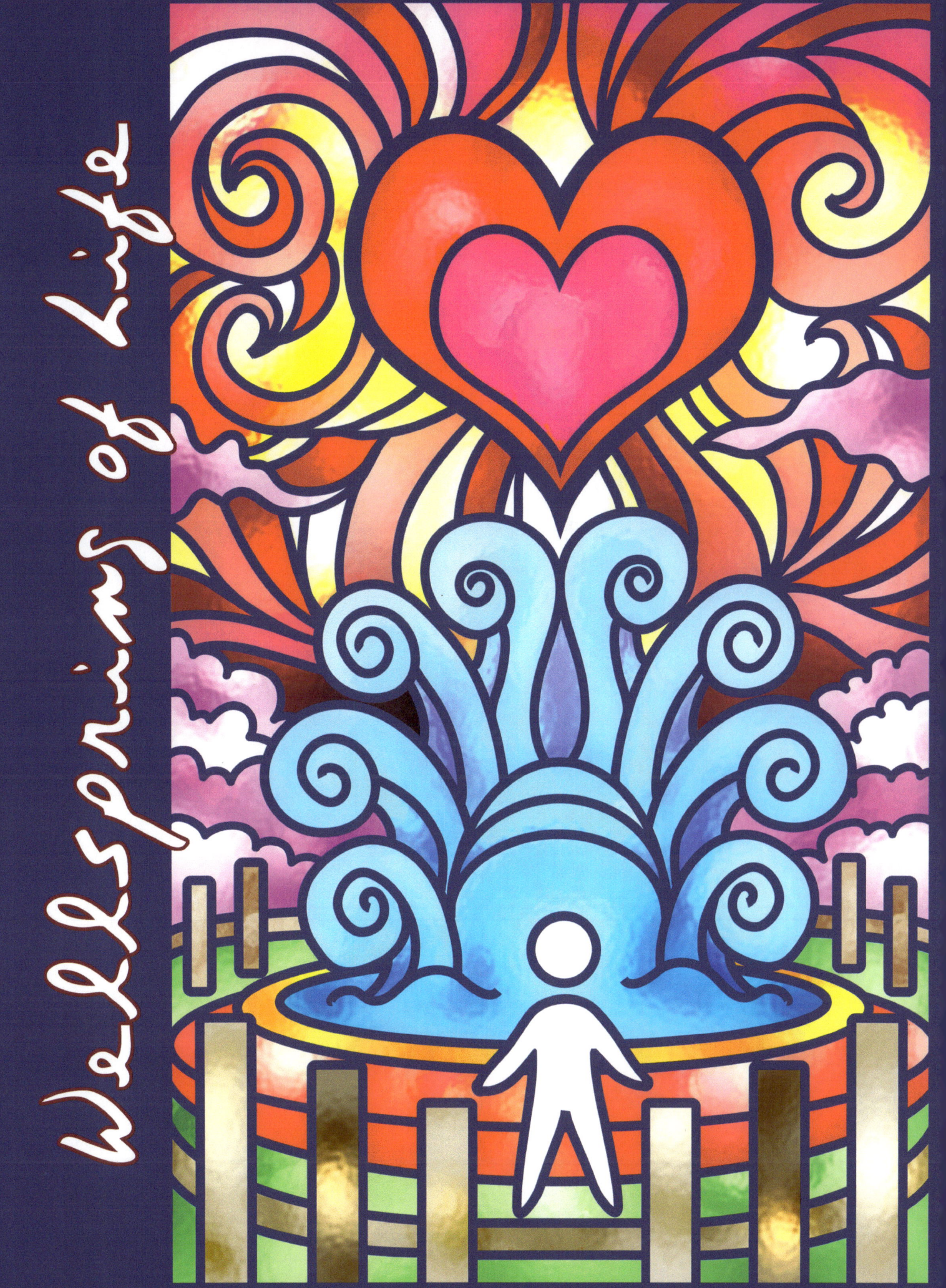

You Are Worth More

" As the deer pants for streams of water,
so my soul pants for you, my God.
My soul thirsts for God, for the living God.
When can I go and meet with God?...
My soul is downcast within me; therefore I will
remember You from the land of the Jordan, the
heights of Hermon—from Mount Mizar.
Deep calls to deep in the roar of Your waterfalls;
all Your waves and breakers have swept over me...
Why, my soul, are you downcast? Why so
disturbed within me?
Put your hope in God, for I will yet praise Him,
my Savior and my God."
Psalm 42: 1-2, 6-7, 11

Deep Calls to Deep

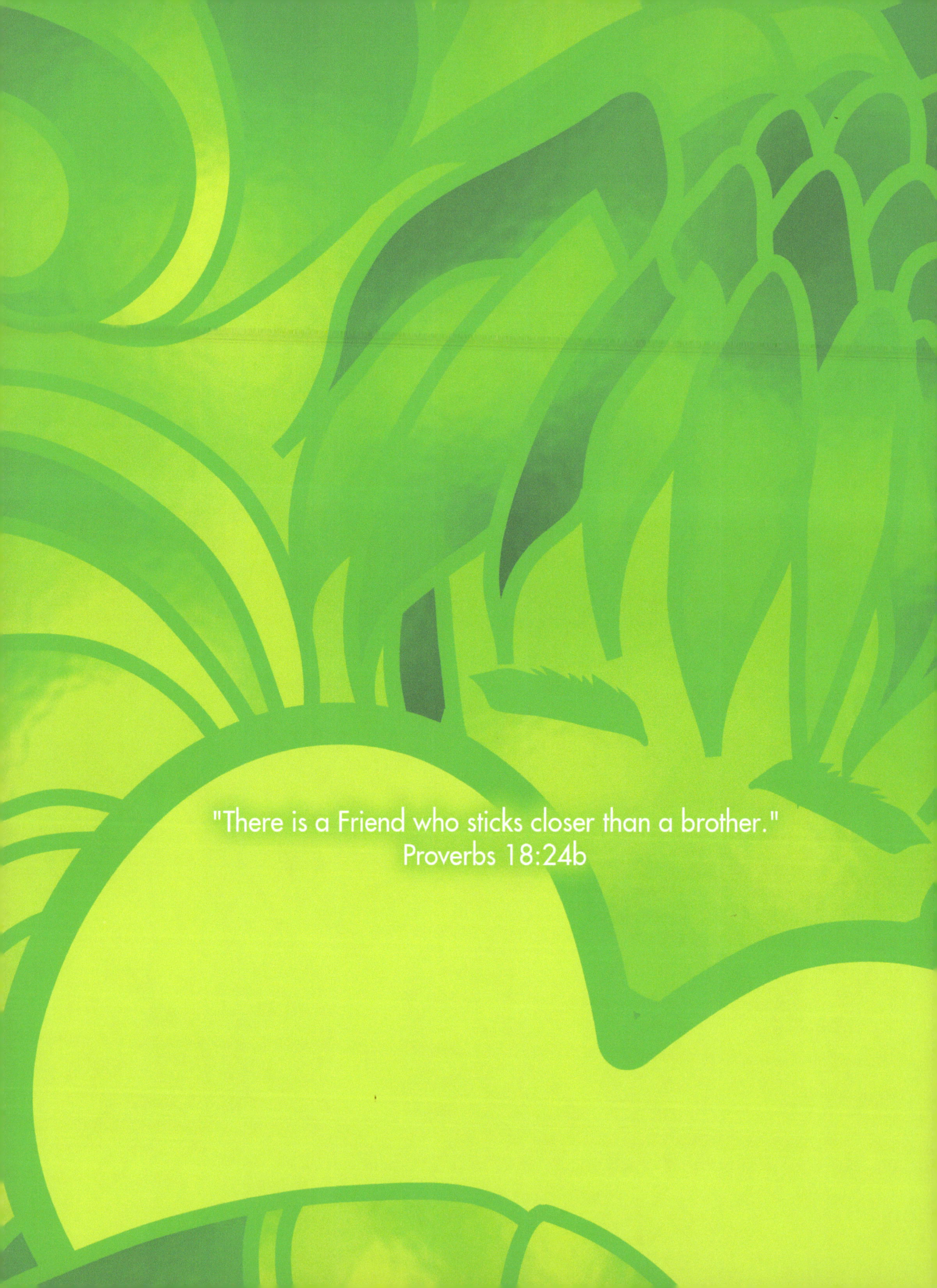

Closer Than a Brother

"You are my hiding place;
You will protect me from trouble
and surround me with songs of deliverance."
Psalm 32:7

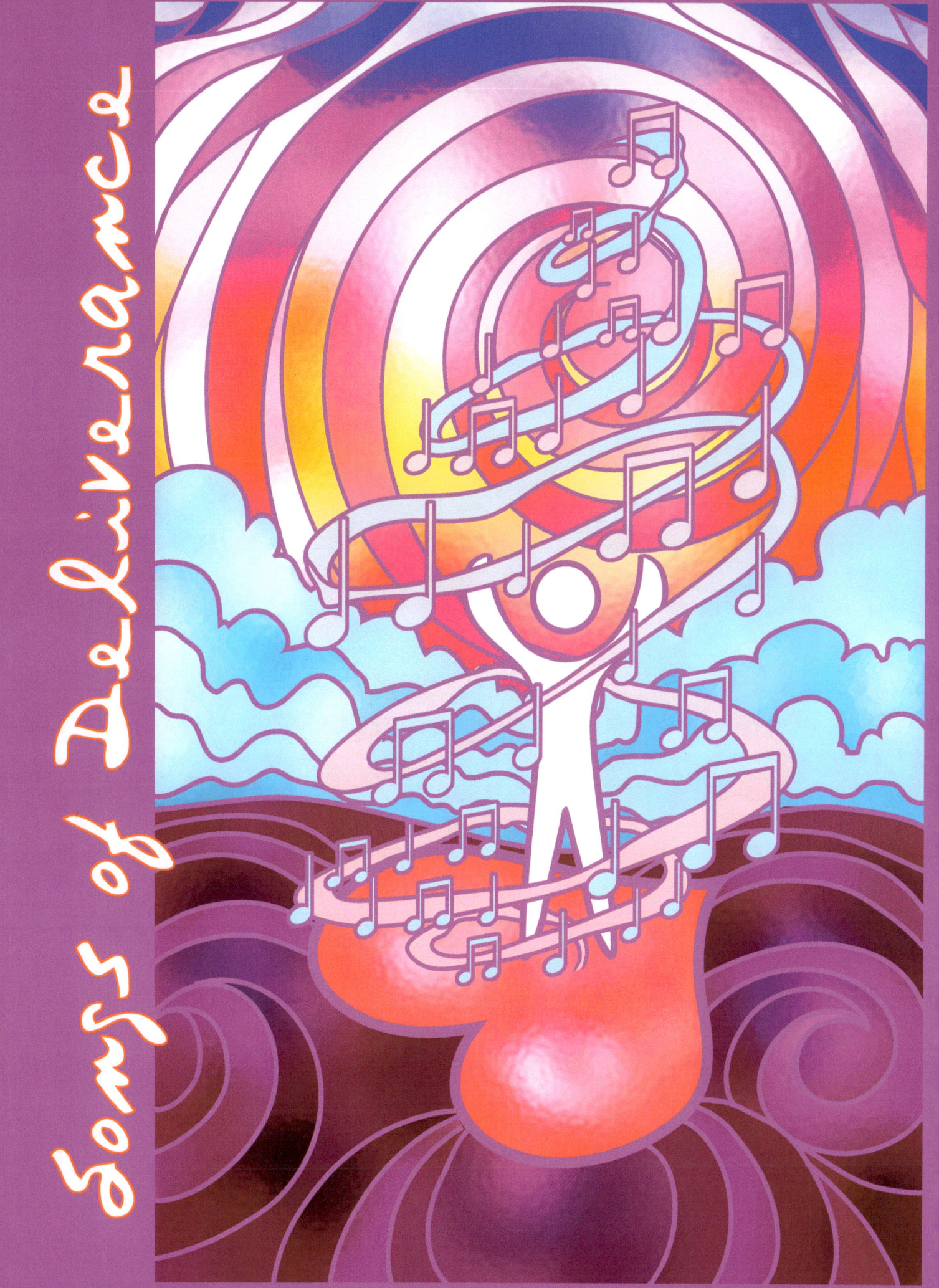

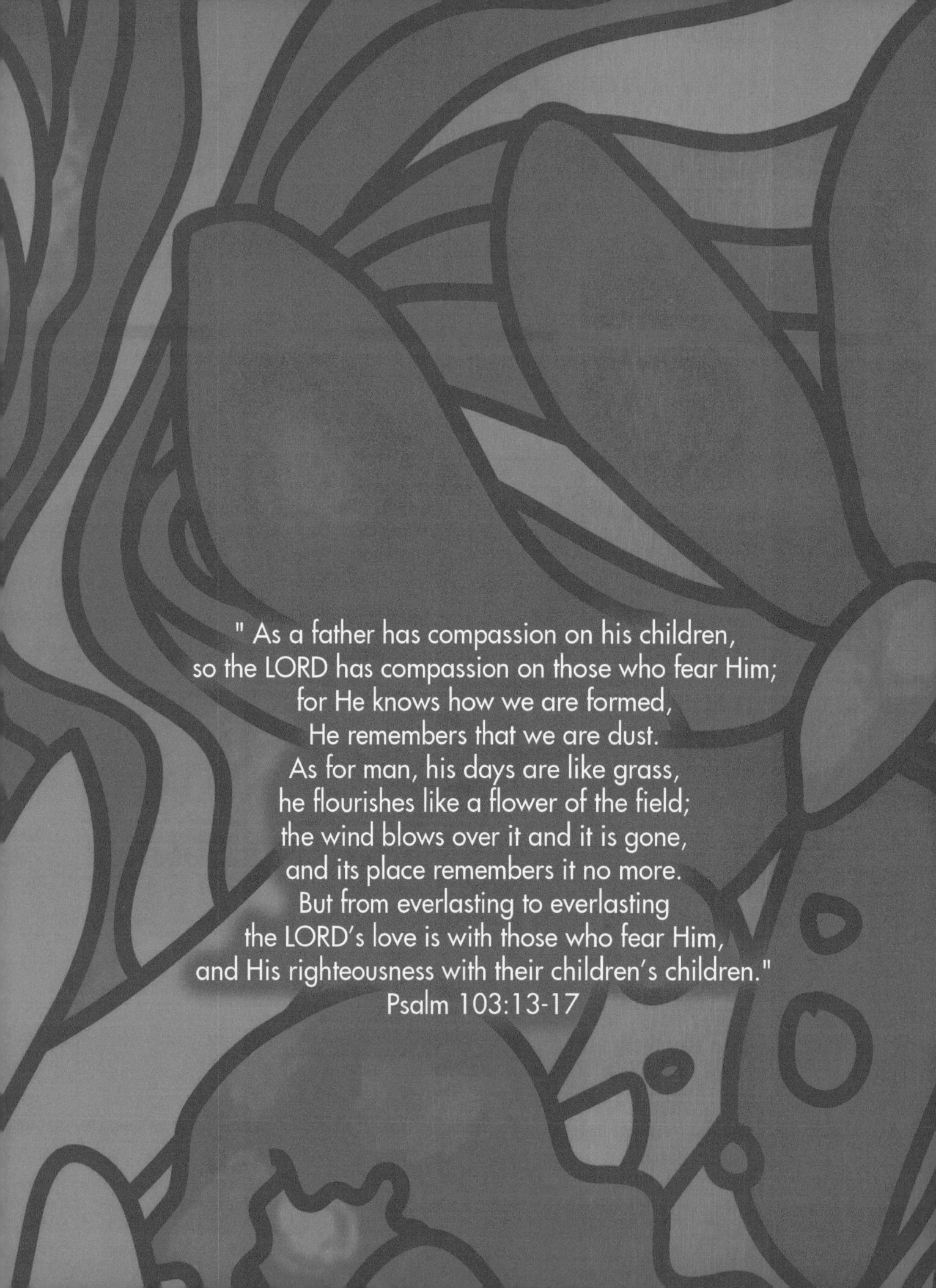

" As a father has compassion on his children,
so the LORD has compassion on those who fear Him;
for He knows how we are formed,
He remembers that we are dust.
As for man, his days are like grass,
he flourishes like a flower of the field;
the wind blows over it and it is gone,
and its place remembers it no more.
But from everlasting to everlasting
the LORD's love is with those who fear Him,
and His righteousness with their children's children."
Psalm 103:13-17

Compassion for the Dust

" When I consider Your heavens,
the work of Your fingers,
the moon and the stars,
which You have set in place,
what is mankind that You are mindful of them,
human beings that You care for them?"
Psalm 8:3-4

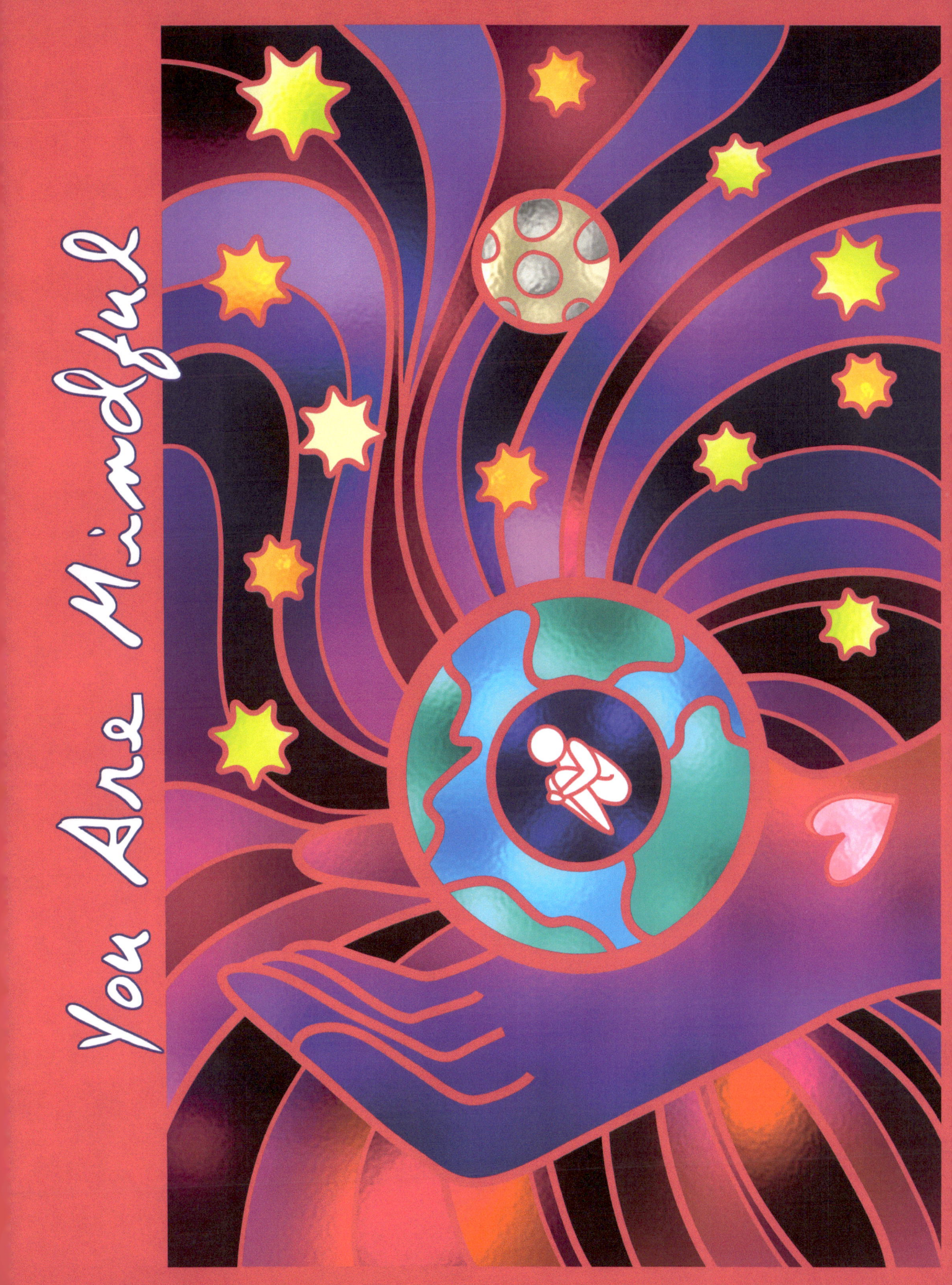

"Go out and stand on the mountain…
for the Lord is about to pass by."
Then a great and powerful wind
tore the mountains apart
and shattered the rocks
before the Lord,
but the Lord was not in the wind.
After the wind there was an earthquake,
but the Lord was not in the earthquake.
After the earthquake came a fire,
but the Lord was not in the fire.
And after the fire came a still small voice.
1 Kings 19:11-12 (NIV and NKJV)

Still Small Voice

"Let the light of your face shine upon us, O LORD. You have filled my heart with greater joy."
Psalm 4:6b-7a

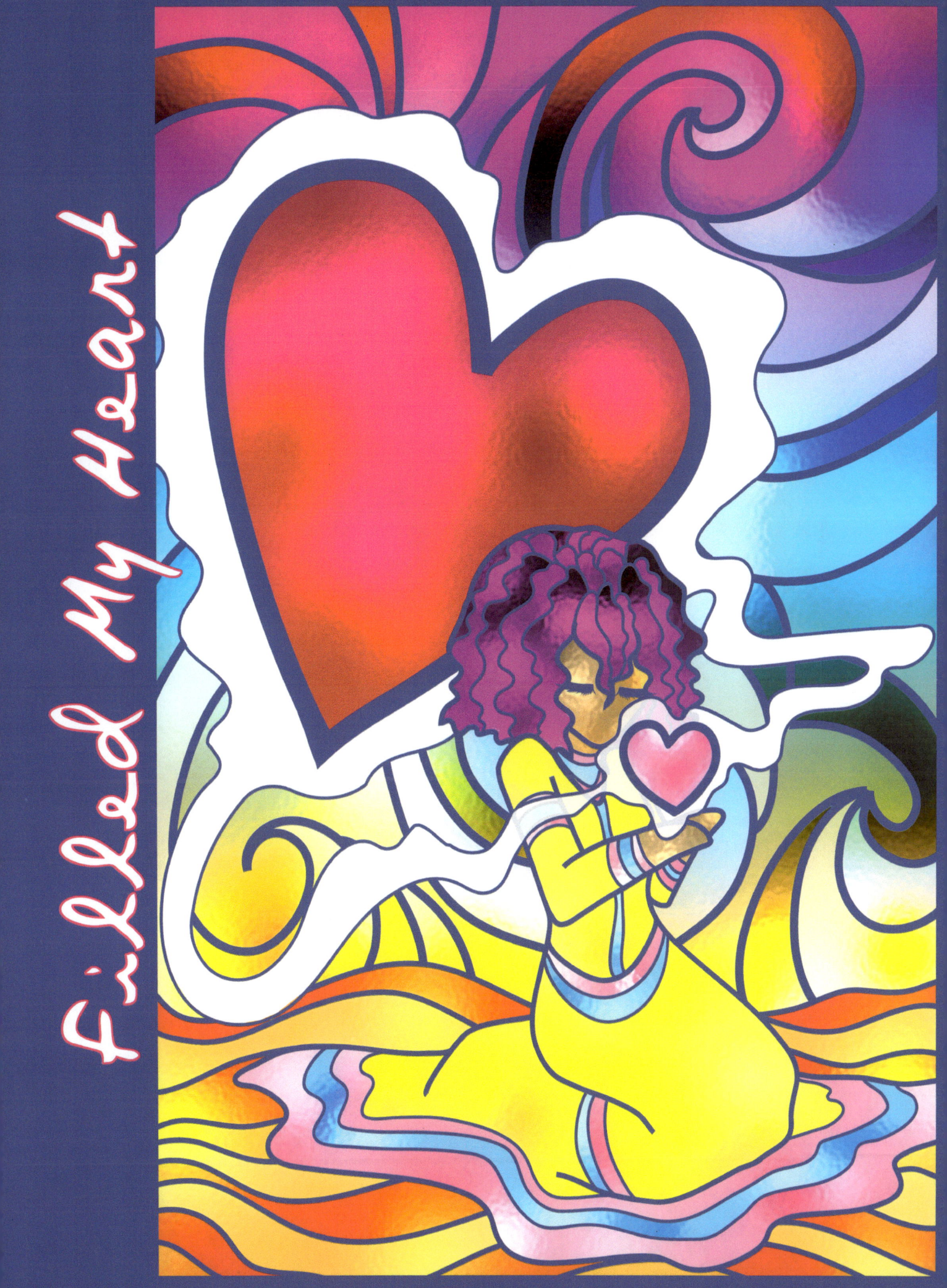

"Ask and it will be given to you; seek and you will find; knock and the door will be opened to you. For everyone who asks receives; the one who seeks finds; and to the one who knocks, the door will be opened."
Matthew 7:7-8

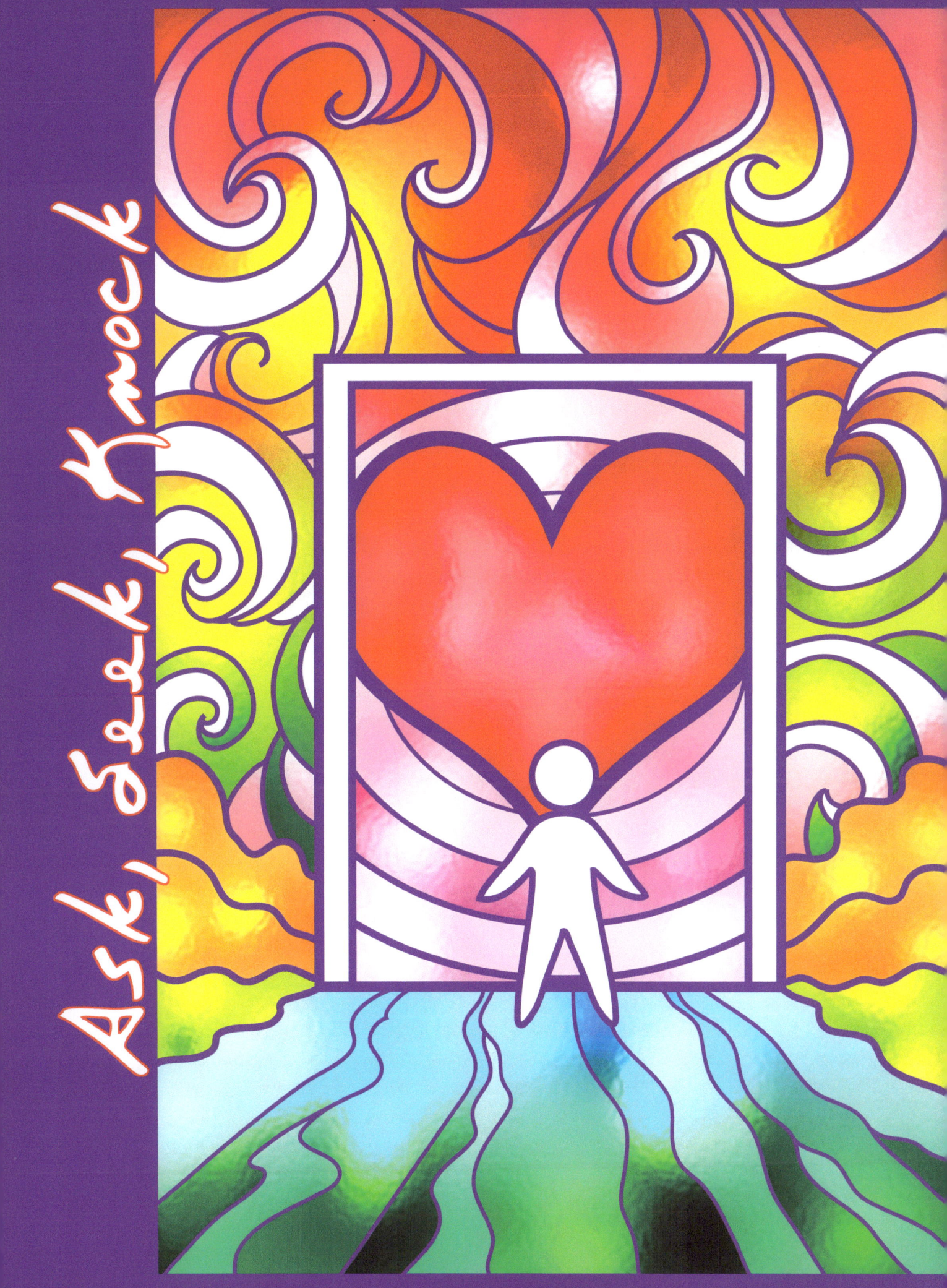

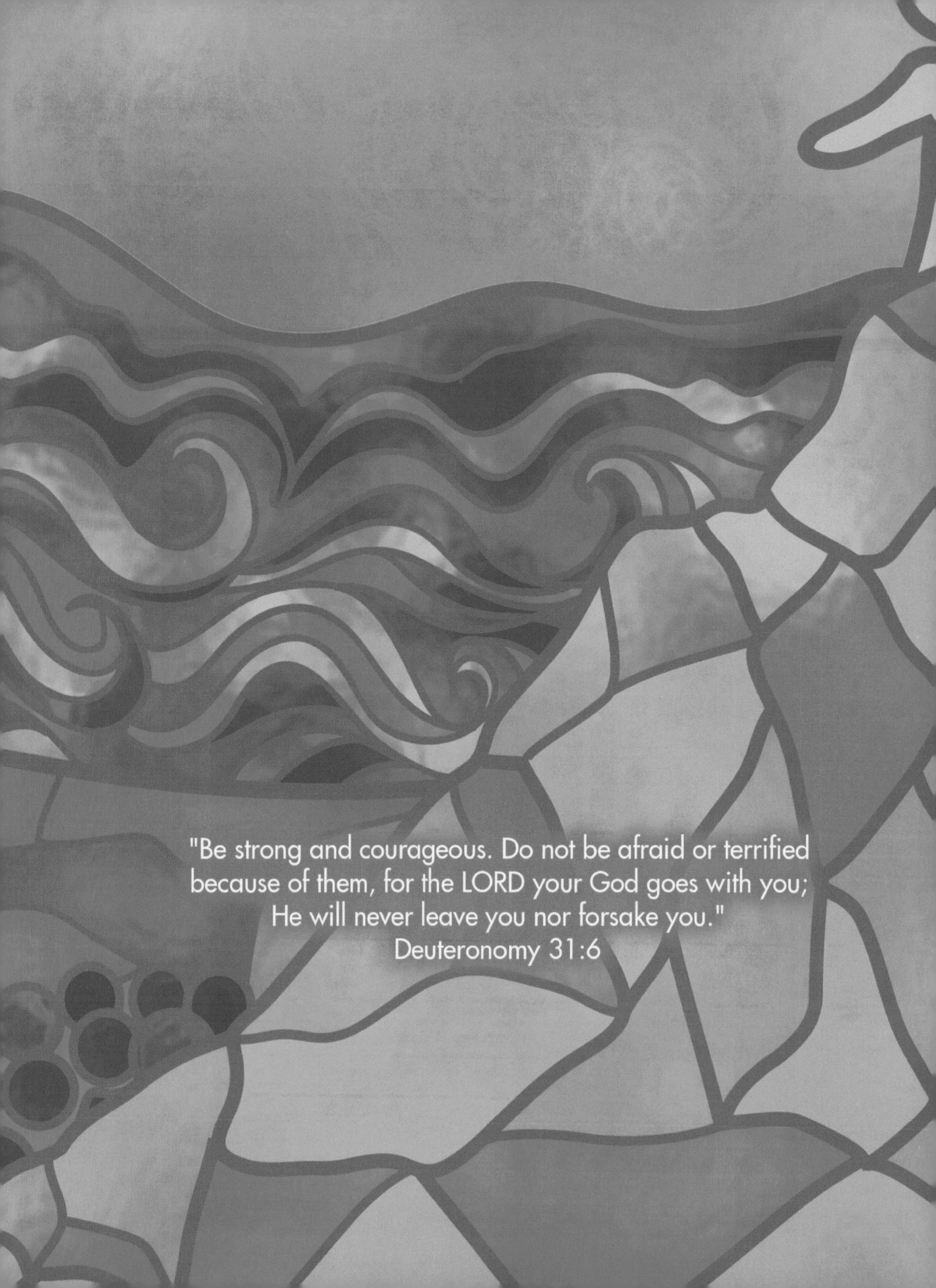

Strong and Courageous

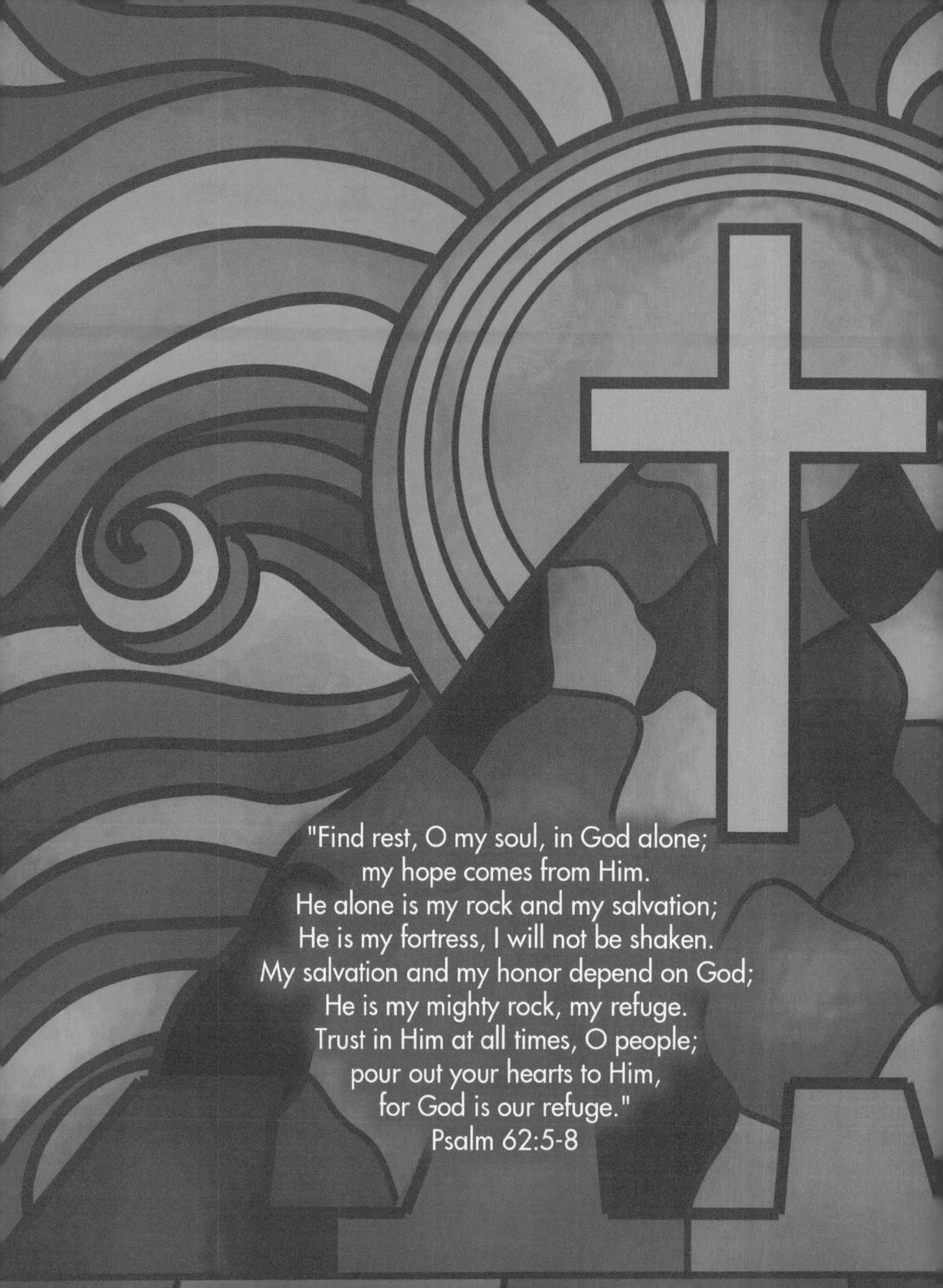

Pour Out Your Hearts

Wait In Expectation

"Your love, O LORD, reaches to the heavens,
your faithfulness to the skies...
How priceless is Your unfailing love!"
Psalm 36:5, 7a

Reaches to the Heavens

> "So, why call it the "Heart" Series? Well, God is Love, isn't He?"

The Heart Series

Collection One

SR

About the Artist:

More commonly known as "Sai", she is a proud follower of Jesus Christ, an avid writer, a dedicated artist, and a lover of cats and manga. She currently resides on the fine line between imagination and eternity.

Email: saredesigns@hotmail.com
Website: saireba.co.nr

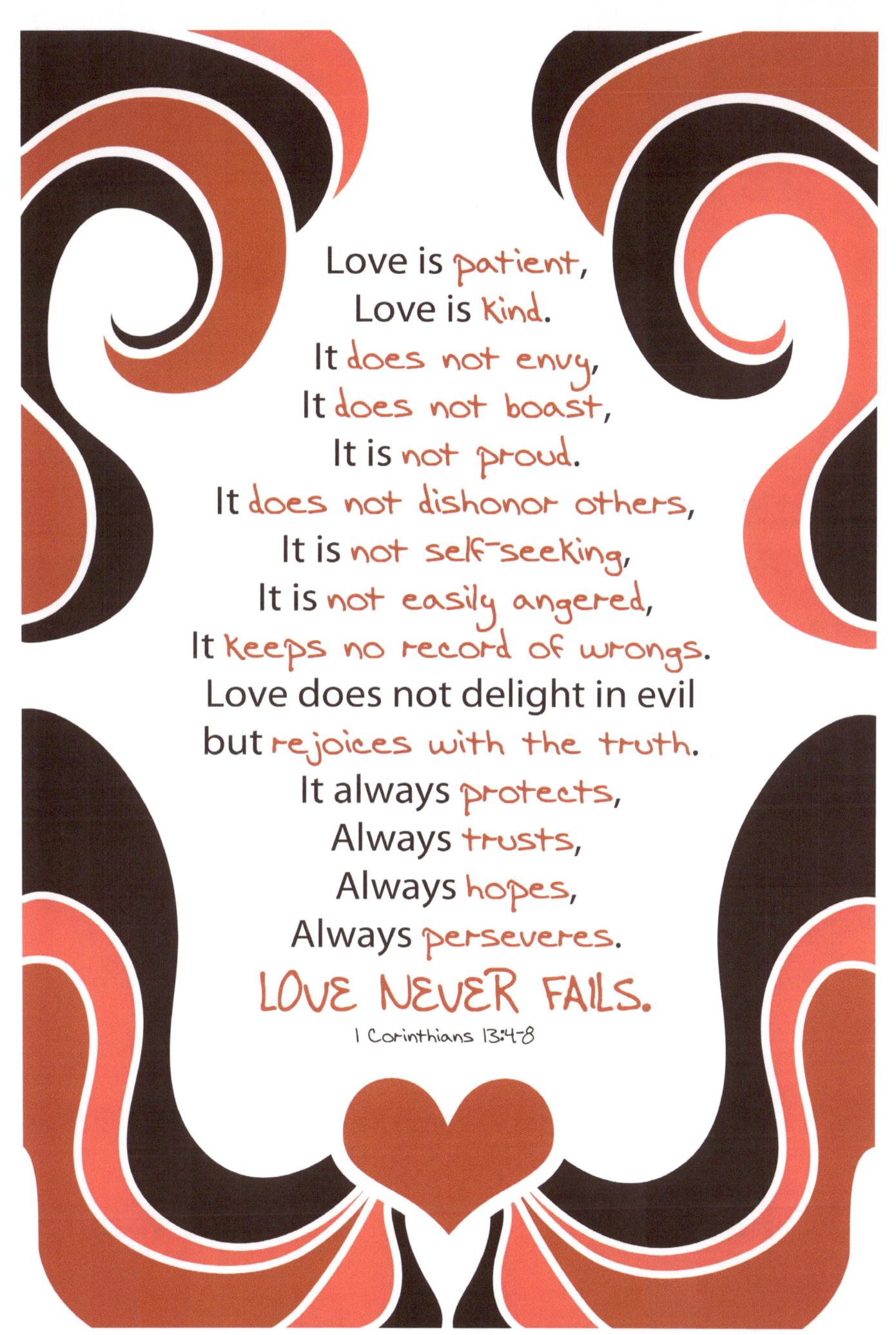

Heart Series images © Sarah Rebecca Designs 2010
Not to be used without artist's permission

Bible scriptures referenced from the NIV 1984 (unless otherwise noted)